Cross-Stitch Patterns in Color

Danish Handcraft Guild

Designs by Gerda Bengtsson

VAN NOSTRAND REINHOLD COMPANY
New York Cincinnati Toronto London Melbourne

Original Danish title: *Vilde Roser og Andre Korsstingsmotiver*

Copyright © 1974 by Haandarbejdets Fremme, Copenhagen (Danish Handcraft Guild). English translation © 1974 Van Nostrand Reinhold Company Ltd.

Translated from the Danish by Christine Hauch

Library of Congress Catalog Card Number 74-7824
ISBN 0-442-21984-9 (cl.)
ISBN 0-442-21985-7 (pb.)

All rights reserved. No part of this work covered by the Copyright hereon may be reproduced or used in any form or by any means – graphic, electronic, or mechanical, including photocopying, recording, taping, or information storage systems – without written permission of the publisher.

Manufactured in the
United States of America

Published by Van Nostrand Reinhold Company, 135 West 50th Street, New York, N.Y. 10020

16 15 14 13 12 11 10 9 8 7 6

Contents

Preface	5
Method of working	6
Materials and instructions	7
Examples of cross-stitch work	10
Wild roses	16
People in town and countryside	40
House plants	58

Suppliers

Danish Evenweave Linens, Danish Flower Thread, and DMC and Filofloss thread are available from Mace and Nairn, 89 Crane Street, Salisbury, Wiltshire, England, and the Artisan's Guild, 10B Street, Burlington, Massachusetts, U.S.A. The Danish Handcraft Guild, 38 Vimmelskaftet, 1161 Copenhagen K, Denmark will also supply materials.

Preface

This collection of cross-stitch work has been drawn up for the Danish Handcraft Guild by the well-known designer Gerda Bengtsson, whose devotion to nature and its faithful representation in stitchery gives this book its special character. So it is right and proper to begin with her impressive pictures of wild roses which show with clarity and beauty her feeling for growing things.

The second group of designs covers the changing seasons, which find expression through a series of pictures of people in landscapes and townscapes.

The book ends with some charming 'flowering windows' in which green and flowering house plants are seen against the light of a window.

The special Danish Flower Thread (see opposite) has been used in all the designs shown in colour. It is a fine, matt, cotton yarn, available in a very wide variety of natural colors similar to those obtained from vegetable dyes. This yarn meets the high standards which Gerda Bengtsson sets for herself and her materials.

Method of Working

A. Sew cross-stitch from left to right. Sew all the under-stitches first. Each under-stitch goes diagonally over two threads from the bottom left corner to the top right. Sew the over-stitches on the way back, to finish the cross.
B. Cross-stitch sewn downwards. Finish each stitch before going on to the next, making sure that the over-stitch lies in the same direction as in diagram A. The wrong side of A and B should look like vertical stitching only.
C. Staggered cross-stitches.
D. Two different versions of back-stitch lines. On the left the top stitch goes two threads to the side and two threads down; the bottom stitch passes over two threads horizontally.
 On the right the top stitch passes over two threads downwards but only one thread to the side, and the fourth stitch goes two threads to the side and one thread down. There are also one vertical stitch and one horizontal stitch.
E (inset). Four back-stitches, two sewn over one thread and two sewn over one intersection of two threads.
F. On the left are four three-quarter cross-stitches. On the right are half cross-stitches, which cover only one thread in one direction and two threads in the other.
N.B. The diagrams do not show the path of needle and thread on the wrong side.

Materials and instructions

The designs in this book have a variety of uses, including place mats, table cloths and runners, tea cosies, cushions, bell pulls, and wall hangings.

This kind of needlework is usually done on fairly fine evenweave linen with about 30 threads to the inch (12 threads to the centimetre), which is referred to in this book as linen I; or on coarser evenweave linen with about 18 threads to the inch (7 threads to the centimetre), referred to as linen II. See also the chart on page 9, which summarizes all the necessary information.

On the pattern diagrams for the rose designs, the centre line of the pattern is indicated by arrows. The actual centre of the pattern lies at the intersection of these two lines.

One square on the diagram is equivalent to two threads on the linen.

The best results will be obtained from the Danish Handcraft Guild's Flower Thread.

Suppliers of all these materials are listed on page 4.

Key to diagrams

Under the diagram for each pattern you can see which color of yarn corresponds to each symbol.

Wherever two different color numbers are given in the section on roses, you should mix the two yarns.

The symbols on the extreme left of the column denote the use of back-stitch.

There will be this much difference in size depending on whether a design is sewn on the coarser linen II, or on the finer linen I. The rose is the Golden Rose of China shown in color on page 23.

8

Chart of the types of linen used, with the number of threads to the inch, and the appropriate yarns and needles:

I = Fine linen, bleached	about 30 threads to the inch (12 threads to the centimetre) on material 54 ins. (140 cm.) wide. Sew with one strand of Danish Flower Thread. Use a tapestry needle number 24 or 25.
II = Coarser linen, bleached	about 18 threads to the inch (7 threads to the centimetre) on material 54 ins. (140 cm.) wide. Sew with two strands of Danish Flower Thread. Use a tapestry needle number 21.

From the chart below, it is easy to work out how much space the individual designs will fill on Linen I, Linen II, and materials with a different number of threads to the inch/centimetre.

Size of pattern	*Roses* 70 × 70 squares	*People* 63 × 63 squares	*Plants* 58 × 58 squares
Linen I: 15 squares = 1 in. (6 squares = 1 cm.)	$4\frac{5}{8}$ ins. ($11\frac{1}{2}$ cm.)	$4\frac{1}{4}$ ins. ($10\frac{1}{2}$ cm.)	$3\frac{7}{8}$ ins. (10 cm.)
Linen II (Canvas): 9 squares = 1 in. ($3\frac{1}{2}$ squares = 1 cm.)	$7\frac{3}{4}$ ins. (20 cm.)	7 ins. (18 cm.)	$6\frac{1}{2}$ ins. ($16\frac{1}{2}$ cm.)

Examples of cross-stitch work

Right. Rosa rugosa is stitched on a cushion cover. The very narrow edging creates a light and attractive frame.

Below. Place mat with Moyes Rose in one corner. A fine hem adds the finishing touches.

Wild roses

It is mainly the rose designs which have been used as illustrated examples, since the other two sets of designs in this book are sewn in a similar way.

Place mats
Linen I, bleached.
Cut material: 19 × 15 ins. (48 × 38 cm.)
Finished measurement: 17 × 12½ ins. (43 × 32 cm.) approx.
Sew this with one thread.
Finish the mat with a hem eight threads wide. The distance from the hem to the motif should be ten threads from the top and ten threads from the sides.

Small table mats
Linen II.
Cut material: 8¼ × 8¼ ins. (21 × 21 cm.)
Finished measurement: 6 × 6 ins. (15 × 15 cm.) approx.
Sew this with one thread.
Make the hem eight threads deep, and stitch it over three threads. See the photograph on page 8.

Cushion
Linen II.
Cut material: 18 × 18 ins. (46 × 46 cm.)
Finished measurement: 13½ × 13½ ins. (34 × 34 cm.) approx.
Sew this with two threads.
When mounting the cushion, give it a narrow green border.

Wall hanging
Linen II, bleached.
Cut material: 13¾ × 13¾ ins. (35 × 35 cm.).
Finished measurement: 11¾ × 11¾ ins. (30 × 30 cm.) approx.
Sew this with two threads.
Mount the embroidery on cardboard measuring 11¾ × 11¾ ins. (30 × 30 cm.) and 1/10 in. (2 mm.) thick. If you want to put it in a glass-fronted frame, make sure the glass is non-reflecting.

Bell pull

Linen I, bleached.
Cut material: $8\frac{1}{4}$ × $45\frac{1}{4}$ ins. (21 × 115 cm.).
Finished measurements: $5\frac{1}{2}$ × $38\frac{1}{2}$ ins. (14 × 98 cm.) approx.
The bell pull consists of seven motifs, placed in the following order: (1) page 25, (2) page 35, (3) page 23, (4) page 31, (5) page 21, (6) page 29, (7) page 27.
Find the centre of the top edge of the linen and measure $3\frac{1}{2}$ ins. (9 cm.) down from there. Count from this point to the nearest leaf and start the embroidery. There should be a distance of 24 threads between each motif.
Finish the bell pull by folding back the linen 20 threads from the embroidery at the sides, and 1 in. ($2\frac{1}{4}$ cm.) from the embroidery at top and bottom.
Mount the bell pull with a narrow edging of green at the sides, and brass rods at the top and bottom.

The wild rose designs look very attractive when grouped together on something like a bell pull, or done in a larger format to hang as a picture. You can buy individual frames complete with glass and a couple of metal clips, which hold the backing, the embroidery, and the glass together unobtrusively.

People in town and countryside

Wall hanging with three motifs

Linen I, bleached.
Cut material: 18 × 9½ ins. (46 x 24 cm.)
Finished measurement: 15 × 6 ins. (38 × 15½ cm.) approx.
Measure 2⅜ ins. (6 cm.) in from the side and top edges at the top left hand corner, and start there. There is a distance of two threads between the motifs.
The finished embroidery is mounted on cardboard. Leave ¾ in. (2 cm.) between the embroidery and the fold.

The designs of people in town and countryside look good when mounted together like this, to form a frieze.

A strong atmosphere of the changing seasons is evoked in a single, larger format landscape design.

Wall hanging

Linen II.
These designs can be made up in exactly the same way as the wall hanging of wild roses.
Cushions and place mats can also be made by following the instructions for the rose designs.

House plants

Wall hanging

Linen II.
Cut material: 19 × 12¼ ins. (48 × 31 cm.).
Finished measurement: 15 × 8¼ ins. (38 × 21 cm.) approx.
Here, the design is repeated.
Measure 2⅜ ins. (6 cm.) in from the side and top in the top left hand corner, and start there.
Mount the finished work on cardboard.
Cushions, wall hangings, and place mats can also be made up from these designs in the same way as from the rose designs.

The house plant designs, too, are very suitable for making up into friezes. In this example, the design has been repeated.

		27 light mauve			212 olive green			222 beige
		4 wine red			6 dark gold-yellow			
		240 black			215 soil colour			
		302 light grey-green			216 deep dark brown			

Scotch Rose
Rosa pimpinellifolia

| | | 3689 light rose pink | | | | ♥ ♥ ♥ ♥ ♥ | 97 dark red | | | | ✴ ✴ ✴ ✴ | 212 olive green |
|---|---|---|---|---|
| O O O O | 93 light carrot | ⊡ ⊡ ⊡ ⊡ | 302 light grey-green | ▢ ▢ ▢ ▢ | 47 green-yellow |
| K K K K | 504 dark orange | △ △ △ △ | 26 yellow-green | 6 6 6 6 | 6 dark gold-yellow |
| O O O O | 95 carrot | ✖ ✖ ✖ ✖ | 323 dark greyish red | ▲ ▲ ▲ ▲ | 216 deep dark brown |

222
beige

215
soil colour

Helen Rose 'Lykkefund'
Rosa helenae hybrida

19

. . / . .	0	white
Z Z / Z Z	303	pale light grey
✳ ✳ / ✳ ✳	19	light grey
I I / I I	3689	light rose pink
⁄ ⁄ / ⁄ ⁄	223	dull light green
U U / U U	40	light green
X X / X X	10	fresh green
Q Q / Q Q	100	medium green
⚡ ⚡ / ⚡ ⚡	323	dark greyish red
⊥ ⊥ / ⊥ ⊥	4	wine red
◌ ◌ / ◌ ◌	302	light grey-green
‖ ‖ / ‖ ‖	48	yellow

123
dark yellow

26
yellow-green

7
sand colour

Ayrshire Rose
Rosa aevensis

Symbol	Number	Colour
- - / - -	31	lemon yellow
↘↘ / ↘↘	123	dark yellow
‖ ‖ / ‖ ‖	48	yellow
▫▫ / ▫▫	47	green-yellow
▲▲ / ▲▲	54	dark orange
╱╱ / ╱╱	223	dull light green
UU / UU	40	light green
╲╳ / ╳╳	10	fresh green
QQ / QQ	100	medium green
▫▫ / ▫▫	302	light grey-green
♦♦	4	wine red
⊞⊞ / ⊞⊞	215	soil colour

Golden Rose of China
Rosa hugonis

Symbol	No.	Color
I I / I I	3689	light rose pink
> > / > >	69	light red
= = / = =	2	light blue-red
H H / H H	37	bright blue-red
T T / T T	53	orange-yellow
- - / - -	31	lemon yellow
∕∕ / ∕∕	223	dull light green
U U / U U	40	light green
× × / × ×	10	fresh green
Q Q / Q Q	100	medium green
K K / K K	9	dull dark green
H H / H H	15	greyish red

14
dark brick red

213
medium brown

12
light brick red

Cinnamon Rose
Rosa cinnamomea

25

Symbol	Code	Name
ℛℛ / ℛℛ	776	pale light red
== / ==	2	light blue-red
HH HH / HH HH	37	bright blue-red
ᚦᚦ / ᚦᚦ	600	bright dark blue-red
∴∴ / ∴∴	0	white
-- / --	31	lemon yellow
TT / TT	53	orange-yellow
UU / UU	40	light green
∕∕ / ∕∕	223	dull light green
++ / ++	101	bright green
×× / ××	10	fresh green
QQ / QQ	100	medium green

6
dark
gold-yellow

Eglantine 'Lucy Bertram'
Rosa eglanteria hybrida

Symbol	Code	Color
.. ..	3689	light rose pink
ZZ ZZ	303	pale light grey
⌄⌄ ⌄⌄	123	dark yellow
∥∥ ∥∥	3688/3689	medium rose pink/ light rose pink
I I I I	3689	light rose pink
1 1 1 1	505	bright yellow-green
T T T T	53	orange-yellow
⁄⁄ ⁄⁄	223	dull light green
UU UU	40	light green
XX XX	10	fresh green
QQ QQ	100	medium green
KK KK	9	dull dark green

6
dark
gold-yellow

Dog Rose
Rosa canina
29

Symbol	Number	Color
♀♀ / ♀♀	899	bright rose pink
≡≡ / ≡≡	86	bright red
●● / ●●	205	dark blue-red
ΓΓ / ΓΓ	600	bright dark blue-red
∕∕ / ∕∕	223	dull light green
∕HH / HH	15	greyish red
UU / UU	40	light green
++ / ++	101	bright green
×× / ××	10	fresh green
QQ / QQ	100	medium green
KK / KK	9	dull dark green
GG / GG	6	dark gold-yellow

216
deep dark
brown

212
olive green

206
dark olive
green

Moyes Rose
Rosa moyesii

		0 white
		3689 light rose pink
		69 light red
		2 light blue-red

		37 bright blue-red
		505 bright yellow-green
		223 dull light green
		40 light green

		101 bright green
		10 fresh green
		100 medium green
		48 yellow

31
lemon yellow

6
dark
gold-yellow

Eglantine
Rosa eglanteria

Symbol	Number	Color
> > / > >	69	light red
= = / = =	2	light blue-red
H H / H H	37	bright blue-red
ΓΓ / ΓΓ	600	bright dark blue-red
T T / T T	53	orange-yellow
1 1 / 1 1	505	bright yellow-green
\ U U / _ U U	40	light green
/ / / / /	223	dull light green
+ + / + +	101	bright green
× × / × ×	10	fresh green
Q Q / Q Q	100	medium green
■ ■ / ■ ■	210	deep dark green

HH / HH	15 greyish red
⊕⊕ / ⊕⊕	82 grey-green
∴ ∴ / ∴ ∴	0 white

Rugosa Rose
Rosa rugosa

Symbol	Number	Color
K K K / K K K	504	dark orange
✳✳ / ✳✳	14	dark brick red
I I / I I	3689	light rose pink
♥♥♥ / ♥♥♥	97	dark red
𝟭𝟭 / 𝟭𝟭	4	wine red
∕ ∕ / ∕ ∕	223	dull light green
⏀ ⏀ / ⏀ ⏀	82	grey-green
✤✤ / ✤✤	212	olive green
△△ / △△	26	yellow-green
G G / G G	6	dark gold-yellow
✕ ✕ / ✕ ✕	10	fresh green
☐ ☐ / ☐ ☐	47	green-yellow

David Rose
Rosa davidii

Symbol	Number	Colour
>	69	light red
≡	86	bright red
♥	97	dark red
⊥	4	wine red
U	40	light green
×	10	fresh green
△	26	yellow-green
∕	223	dull light green
⊕	302	light grey-green
6	6	dark gold-yellow
●	206	dark olive green
⊞	215	soil colour

212
olive green

Eglantine
Rosa eglanteria

			227 blue
			220 dull dark blue
			35 very light grey
			19 light grey

			20 grey
			147 darkest grey
			86 bright red
			216 deep dark brown

			10 fresh green
			25 flesh colour

Skating

227 blue	32 dark grey	215 soil colour
220 dull dark blue	222 beige	216 deep dark brown
35 very light grey	13 dull brick red	8 dark verdigris green
20 grey	214 reddish brown	40 light green

9
dull dark green

25
flesh colour

6
dark gold-yellow

Skipping

43

Symbol	Number	Color
	227	blue
	220	dull dark blue
	35	very light grey
	19	light grey
	32	dark grey
	86	bright red
	13	dull brick red
	213	medium brown
	216	deep dark brown
	10	fresh green
	9	dull dark green
	25	flesh colour

48
yellow

203
light
gold-yellow

April Showers

45

Symbol	Number	Colour
	227	blue
	220	dull dark blue
	35	very light grey
	20	grey
	32	dark grey
	86	bright red
	13	dull brick red
	216	deep dark brown
	40	light green
	10	fresh green
	9	dull dark green
	25	flesh colour

203
light
gold-yellow

Sunday Outing

227	147	216
blue	darkest grey	deep dark brown
220	13	99
dull dark blue	dull brick red	light verdigris green
20	213	223
grey	medium brown	dull light green
32	215	10
dark grey	soil colour	fresh green

100
medium green

25
flesh colour

16
pale light yellow

203
light gold-yellow

6
dark gold-yellow

0
white

Harvest

49

Symbol	No.	Colour
	227	blue
	220	dull dark blue
	35	very light grey
	32	dark grey
	222	beige
	13	dull brick red
	214	reddish brown
	215	soil colour
	40	light green
	9	dull dark green
	25	flesh colour
	48	yellow

	3	3		3	3		
	3	3		3	3		
		⊼	⊼		⊼	⊼	
		⊼	⊼		⊼	⊼	
	⁄				O	O	
⁄	⁄	⁄			O	O	
		♥	♥		♥	♥	
	♥	♥		♥	♥		

203
light
gold-yellow

6
dark
gold-yellow

34
dark
yellow-green

212
olive green

Behind the Plough

	227	blue
	220	dull dark blue
	5	mauve
	35	very light grey
	20	grey
	32	dark grey
	213	medium brown
	216	deep dark brown
	40	light green
	223	dull light green
	10	fresh green
	100	medium green

9	dull dark green
25	flesh colour
203	bright gold-yellow
34	dark yellow-green
86	bright red

Gathering Mushrooms

53

	227 blue
	35 very light grey
	19 light grey
	20 grey

	32 dark grey
	147 darkest grey
	222 beige
	213 medium brown

	215 soil colour
	224 verdigris green
	9 dull dark green
	25 flesh colour

203
light
gold·yellow

212
olive green

Autumn Storm

227 blue	32 dark grey	96 brick red
220 dull dark blue	147 darkest grey	15 greyish red
35 very light grey	222 beige	214 reddish brown
20 grey	13 dull brick red	215 soil colour

100
medium green

9
dull dark green

25
flesh colour

6
dark gold-yellow

34
dark yellow-green

Christmas Trees

57

228	dull blue
229	dull light blue
40	light green
10	fresh green
100	medium green
9	dull dark green
15	greyish red
215	soil colour
0	white
96	brick red
69	light red
2	light blue-red

37
bright
blue-red

97
dark red

Azalea (1)
Azalea indica

Cyclamen (2)　Snowdrop (4)
Cyclamen　　*Galanthus nivalis*

Ivy (3)　　　Weeping Ficus (5)
Hedera Helix　*Ficus pumila*

59

Symbol	No.	Color
	228	dull blue
	229	dull light blue
	23	lavender blue
	27	light mauve
	5	mauve
	48	yellow
	34	dark yellow green
	10	fresh green
	100	medium green
	9	dull dark green
	96	brick red
	69	light red

2	light blue-red
37	bright blue-red
205	dark blue-red

Hyacinth (6-9)
Hyacinthus orientalis

Ladder Fern (10)
Nephrolepis exaltata

Winter Aconite (11)
Eranthis

Saxifrage (12)
Tolmiea Menziesii

61

228 dull blue	40 light green	12 light brick red
229 dull light blue	10 fresh green	96 brick red
48 yellow	100 medium green	2 light blue-red
223 dull light green	9 dull dark green	37 bright blue-red

Lilac Primula (13)
Syringa primula

Primula (14) *Scindapsus aureus* (16)
Primula *Peperomia* (17)

Lilac Primula (15) Tradescantia (18)
Syringa primula *Tradescantia albiflora*

228
dull blue

229
dull light blue

17
cornflower blue

223
dull light green

99
light verdigris green

224
verdigris green

10
fresh green

100
medium green

9
dull dark green

96
brick red

37
bright blue-red

Cineraria (19)
Senecio cruentus
Cineraria (20)
Senecio cruentus
Climbing Asparagus (21)
Asparagus Sprengeri
Chlorophytum (22)

228	dull blue
229	dull light blue
31	lemon yellow
203	light gold-yellow
223	dull light green
10	fresh green
100	medium green
9	dull dark green
0	white
12	light brick red
13	dull brick red
96	brick red

69 light red

2 light blue-red

37 bright blue-red

3 pastel rose pink

88 blue-red

Prickly Pear (23)
Opuntia

Epiphyllum (24)

Epiphyllum (25)

Hedgehog Cactus (26)
Ferocactus

Epiphyllum (27)

Prickly Pear (28)
Opuntia

Rat-tail Cactus (29)
Aporocactus flagelliformis

Nopalxochia phyllanthoides (30)

Rat-tail Cactus (31)
Aporocactus flagelliformis

67

✕	228	dull blue
▯	229	dull light blue
M	212	olive green
◈	8	dark verdigris green
+	224	verdigris green
♡	40	light green
✕	10	fresh green
●	100	medium green
▪	9	dull dark green
✣	96	brick red
H	2	light blue-red
O	37	bright blue-red

86
bright red

4
wine red

Geranium (32)
Pelargonium

Ivy (33)
Hedera helix

Geranium (34)
Pelargonium

Aeschynauthus marmorata (35)

Geranium (36)
Pelargonium

Tradescantia (37)
Tradescantia albiflora

69

Symbol	No.	Color
	228	dull blue
	229	dull light blue
	5	mauve
	48	yellow
	40	light green
	10	fresh green
	100	medium green
	9	dull dark green
	13	dull brick red
	96	brick red
	69	light red
	2	light blue-red

37	bright blue-red
88	blue-red
4	wine red

Shrimp Plant (38)
Beloperone guttata

African Violet (39)
Saintpaulia ionantha

Hibiscus (40)
Hibiscus rosasinensis

Mother of Thousands (41)
Saxifraga sarmentosa

Nasturtium (42)
Tropaeolium majus

Twining Geranium (43)
Pelargonium peltatum

Symbol	Number	Color
⋈	228	dull blue
▬ ▭	229	dull light blue
ℓ ℓ	304	light blue
⋅⋅	33	very light blue
⊕	22	light cornflower blue
∕∕	223	dull light green
◆ ◇	8	dark verdigris green
♡	40	light green
⋋⋌ ⋈	10	fresh green
•	100	medium green
■	9	dull dark green
△	35	very light grey

96
brick red

Crassula (44)
Crassula lucens
Morning Glory (45)
Ipomoea
Echeveria retusa (46)

228	dull blue	
229	dull light blue	
11	reddish mauve	
4	wine red	

225	light yellow-green	
203	light gold-yellow	
26	yellow-green	
40	light green	

10	fresh green	
100	medium green	
9	dull dark green	
0	white	

96
brick red

Aralia Ivy (47)
Fatshedera Lizei

Tradescantia (48)
Rhoeo discolor

Cups and Saucers (49)
Cobaea scandens

75

228 dull blue	11 reddish mauve	212 olive green
229 dull light blue	48 yellow	40 light green
304 light blue	26 yellow-green	10 fresh green
27 light mauve	34 dark yellow-green	100 medium green

	15	greyish red
	215	soil colour
	96	brick red
	2	light blue-red
	37	bright blue-red
	3	pastel rose pink

Passion Flower (50)
Passiflora

Coleus (51)
Coleus

Sanchezia nobilis (52)

77

228 dull blue	10 fresh green	96 brick red
229 dull light blue	100 medium green	2 light blue-red
26 yellow-green	9 dull dark green	37 bright blue-red
40 light green	15 greyish red	95 carrot

86	bright red
97	dark red

Winter-flowering
Begonia (56)
Begonia cheimantha

Poinsettia (57)
Euphorbia pulcherrima

Kalanchoë Blossfeldiana (58)

Christmas Cactus (59)
Zygocactus truncatus

Tulip (60)
Tulipa Gesneriana

Christmas Cactus (61)
Zygocactus truncatus